SGADIN BIDYXARI NRABBI MILLO DOMESICA DISECTO

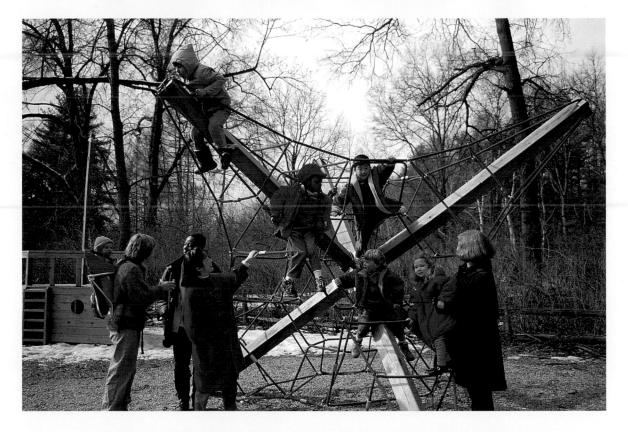

SHELLEY ROTNER and SHEILA M. KELLY photographs by SHELLEY ROTNER

Dial Books for Young Readers New York

FRANKLIN PIERCE COLLEGE LIBRARY RINDGE, N.H. 03461 Published by Dial Books for Young Readers A Division of Penguin Books USA Inc. 375 Hudson Street New York, New York 10014

Text copyright © 1996 by Shelley Rotner and Sheila M. Kelly Photographs copyright © 1996 by Shelley Rotner All rights reserved Printed in Hong Kong First Edition 1 3 5 7 9 10 8 6 4 2

Library of Congress Cataloging in Publication Data Rotner, Shelley. Lots of moms / by Shelley Rotner and Sheila M. Kelly ; photographs by Shelley Rotner.—1st ed.

p. cm.

Summary: Photographs and brief text depict a variety of mothers engaged in different activities, with emphasis on the similarities of mothers everywhere.
ISBN 0-8037-1891-8 (trade).—ISBN 0-8037-1892-6 (library)
1. Mothers—Pictorial works—Juvenile literature. [1. Mothers.]
I. Kelly, Sheila M. II. Title.
HQ759.R685 1996

306.874'3'0222—dc20 95-7789 CIP AC

URR-HQ

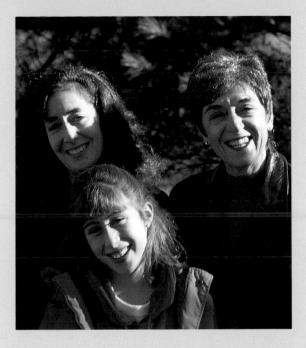

For my mom.

SHELLEY ROTNER

(left, with her mother and daughter) is the creator of numerous highly praised photo books for children, including *Faces, Citybook,* and *Changes.* She lives in Northampton, Massachusetts.

For the many dedicated mums and moms in my life.

SHEILA M. KELLY, ED.D.

(right, with her mother) is a child clinical psychologist in private practice who specializes in working with preschool and primary-age children. She lives in Greenfield, Massachusetts.

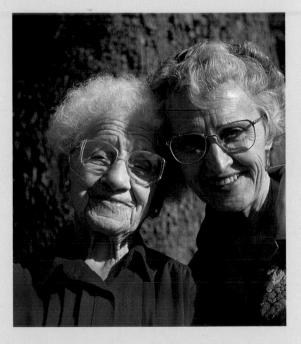

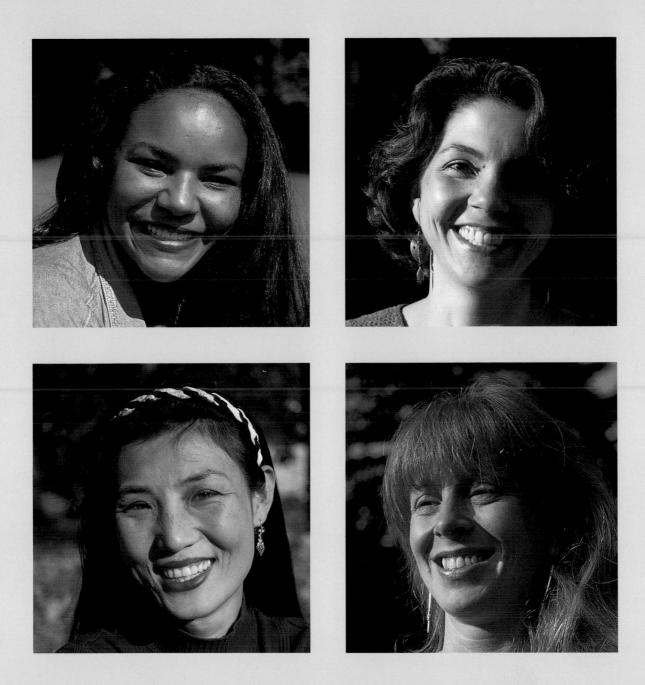

There are lots of moms everywhere.

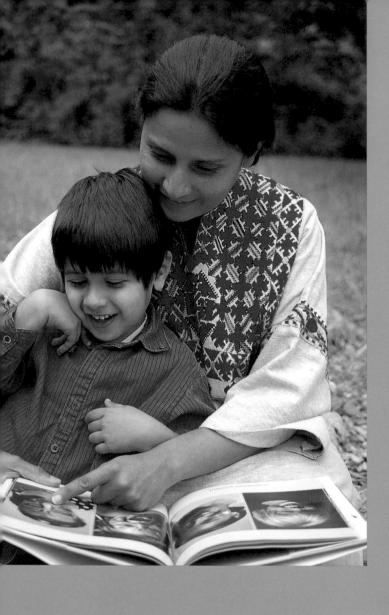

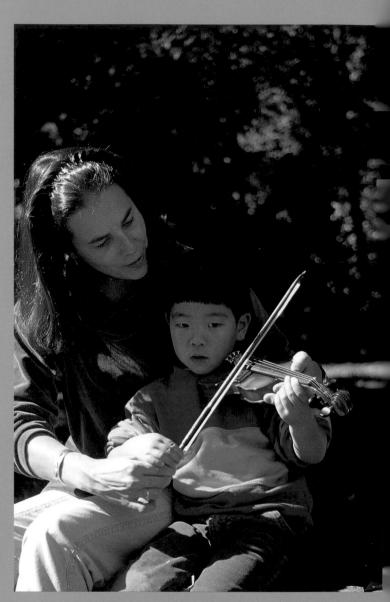

They teach you,

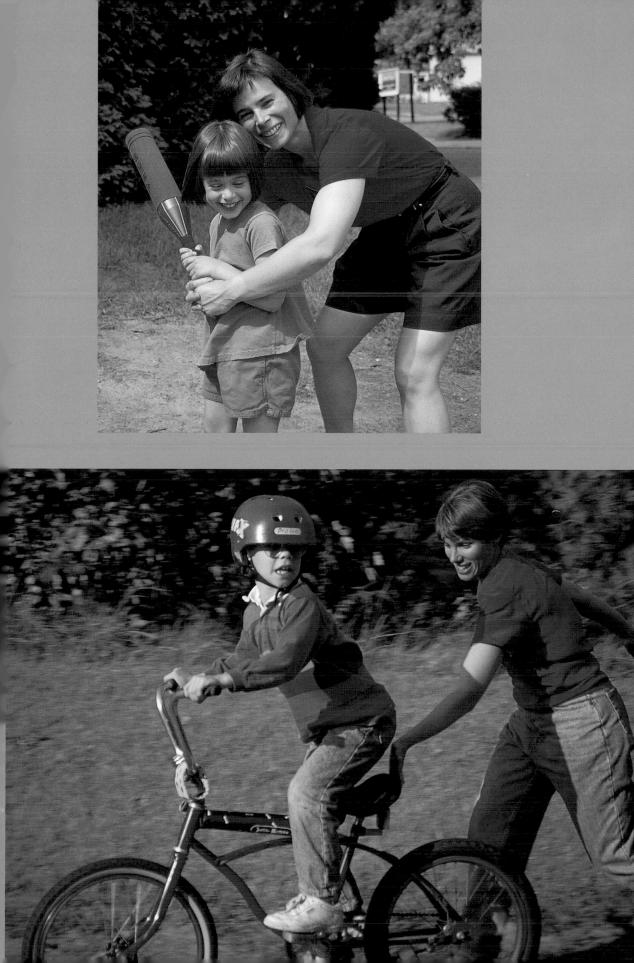

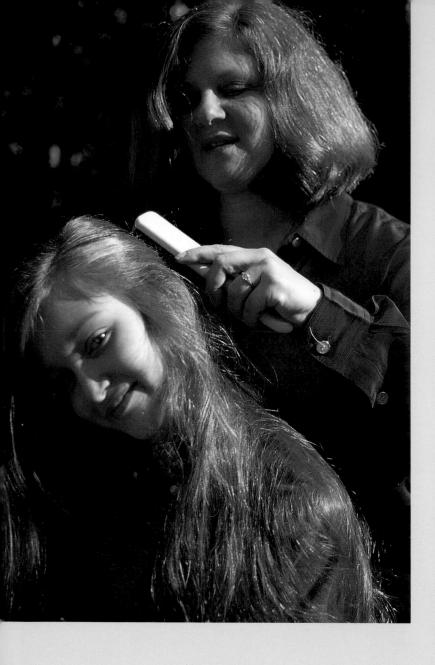

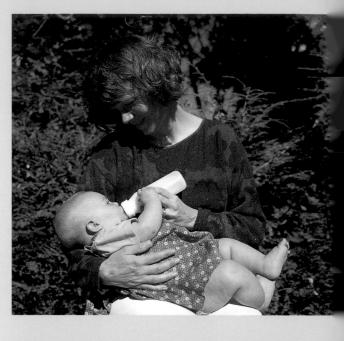

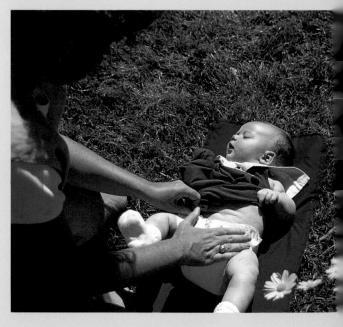

take care of you,

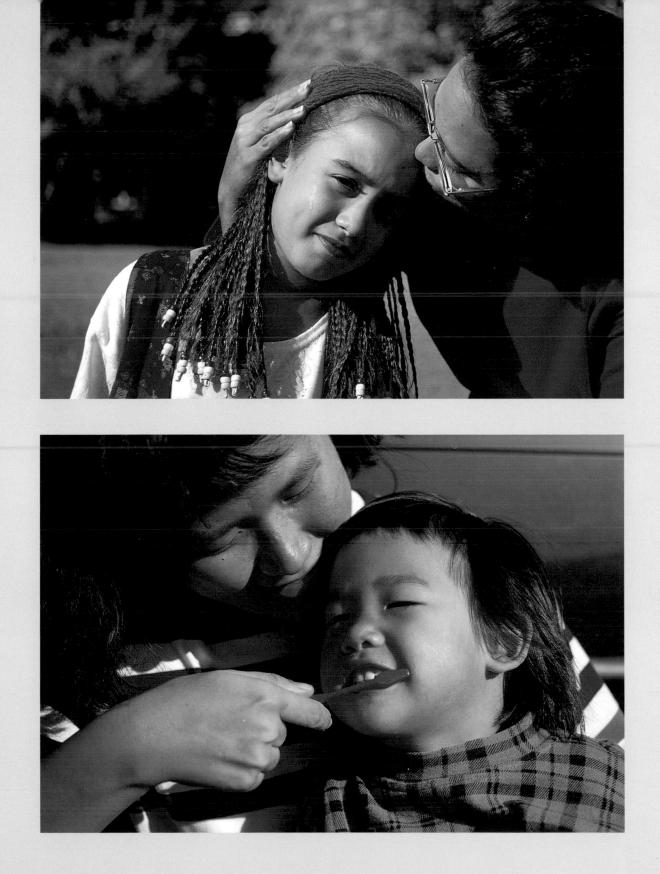

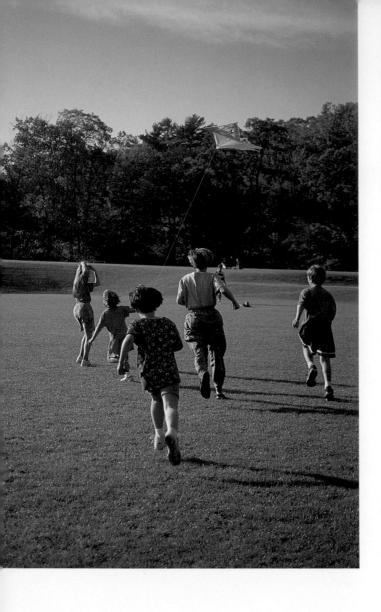

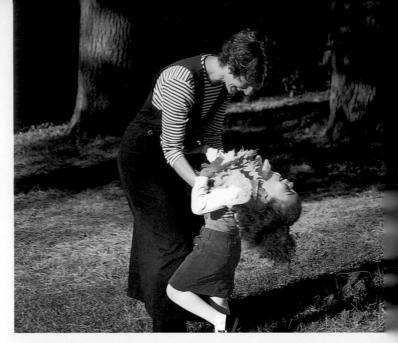

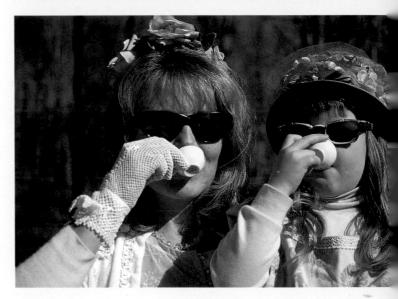

and play with you.

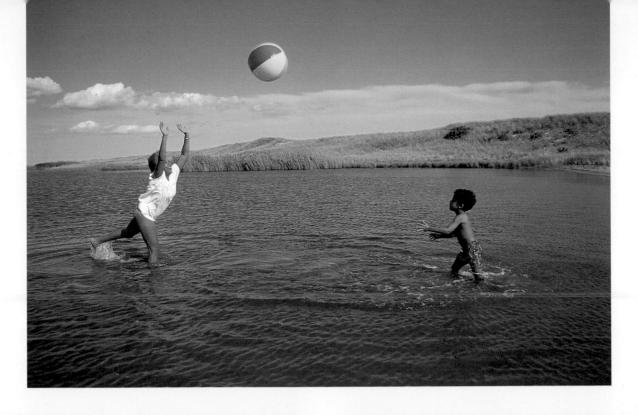

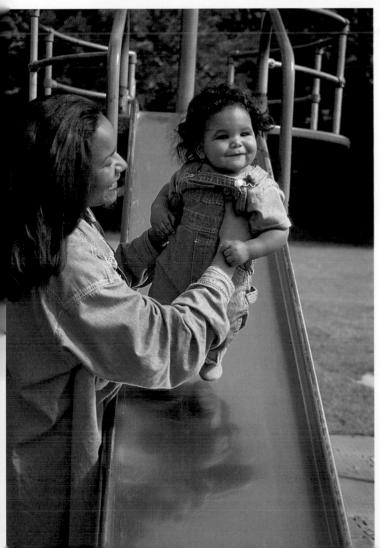

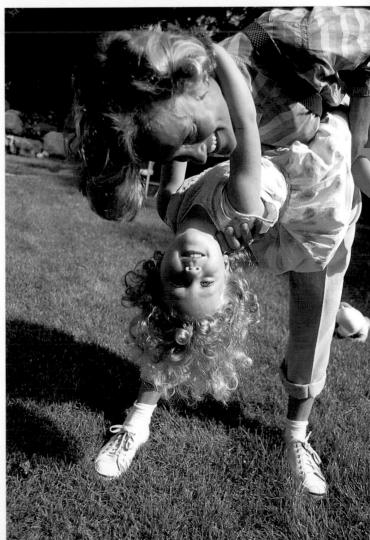

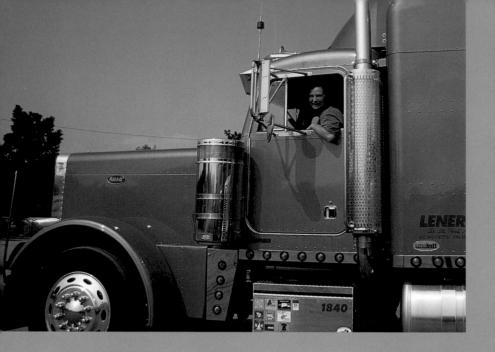

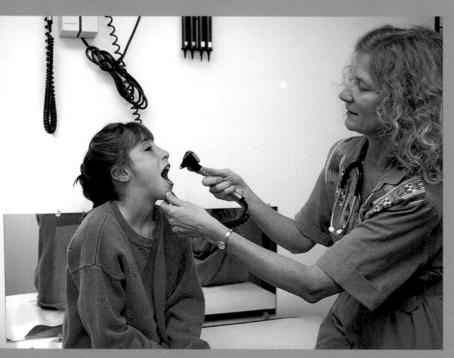

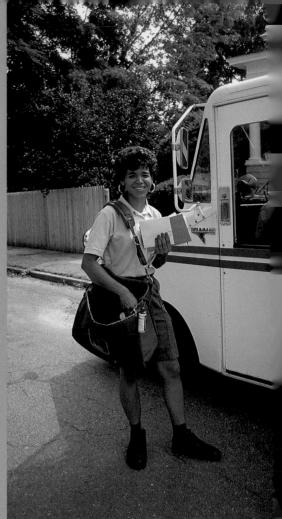

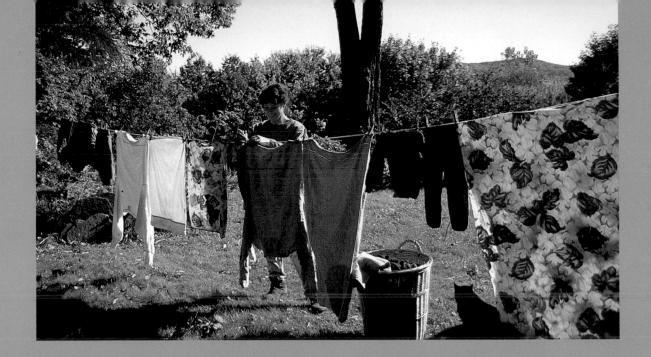

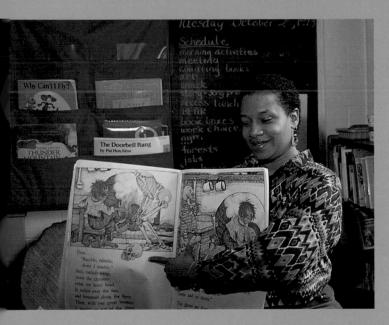

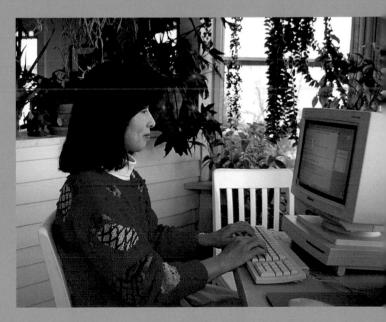

Sometimes they're busy working.

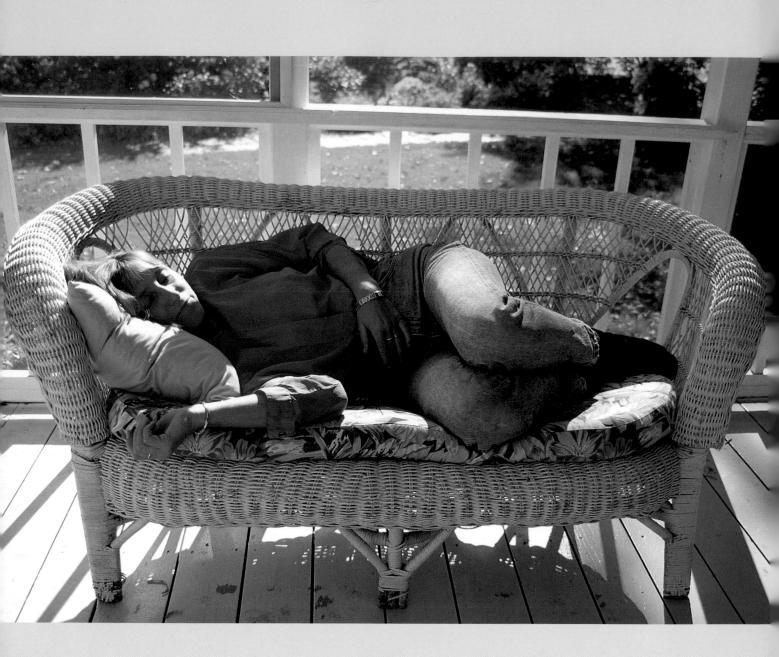

Sometimes they're tired

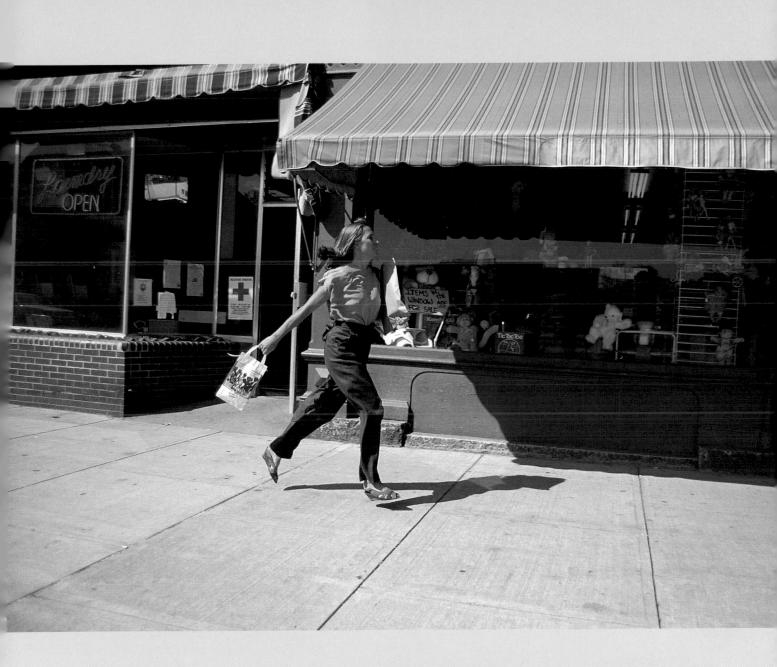

and sometimes they're in a big rush.

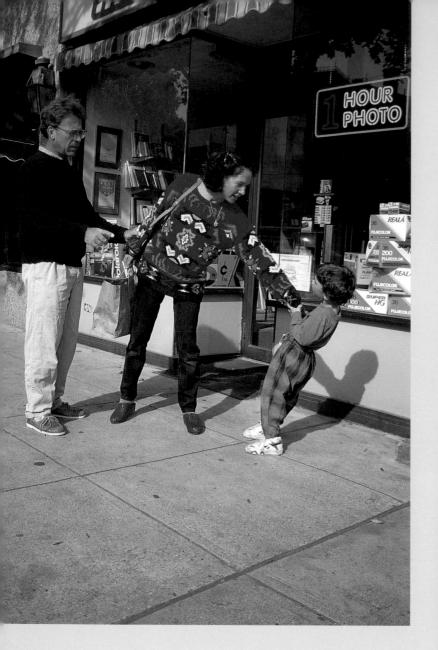

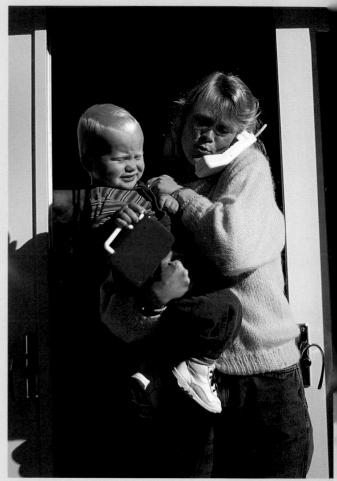

They tell you, "Wait a minute."

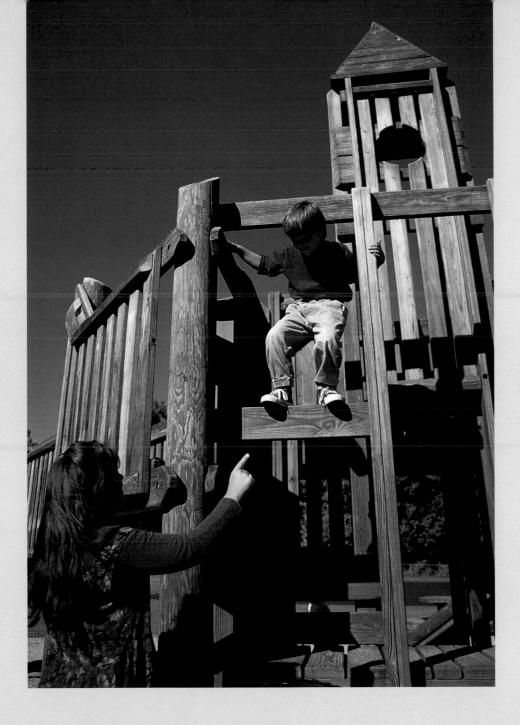

They say, "Be careful," and sometimes, "No!"

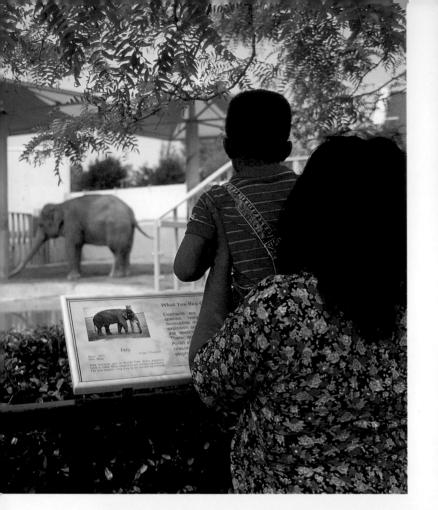

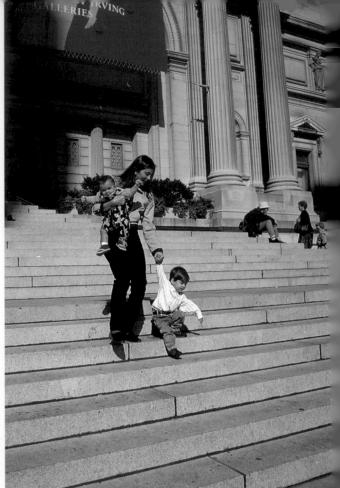

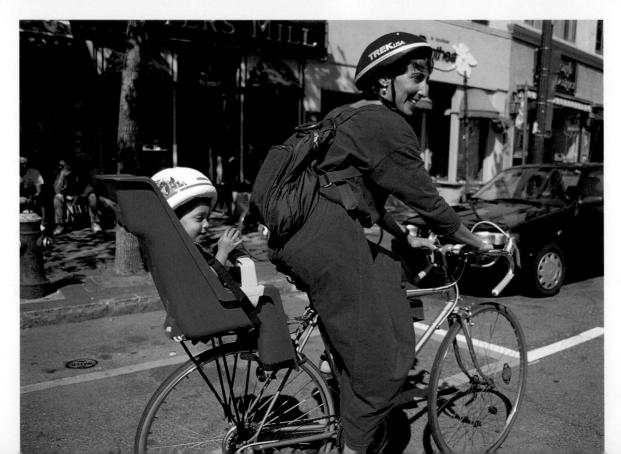

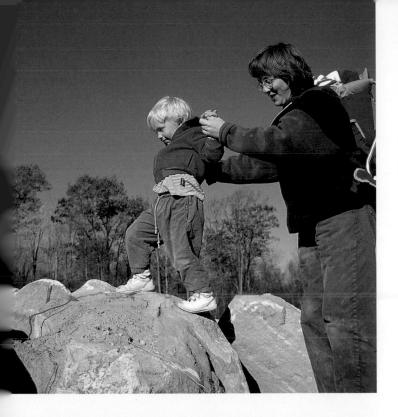

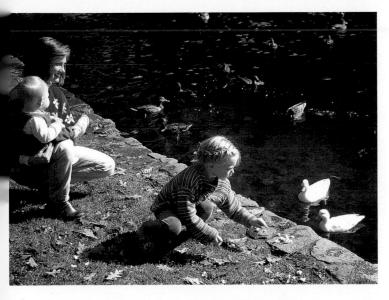

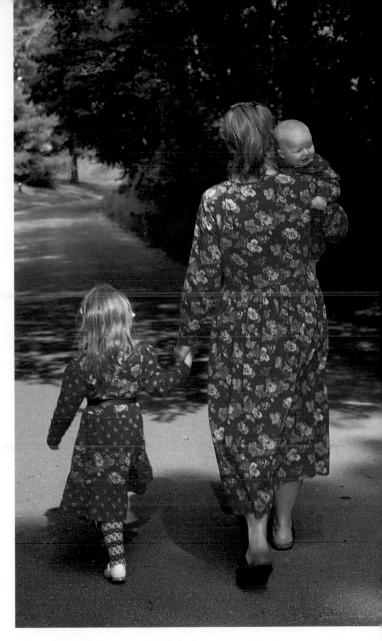

They take you to different places.

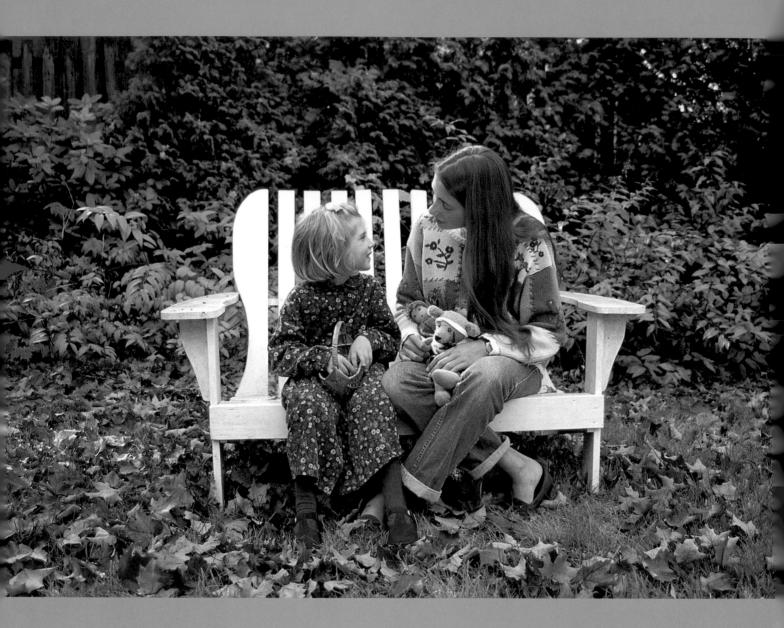

Sometimes they leave you with a sitter,

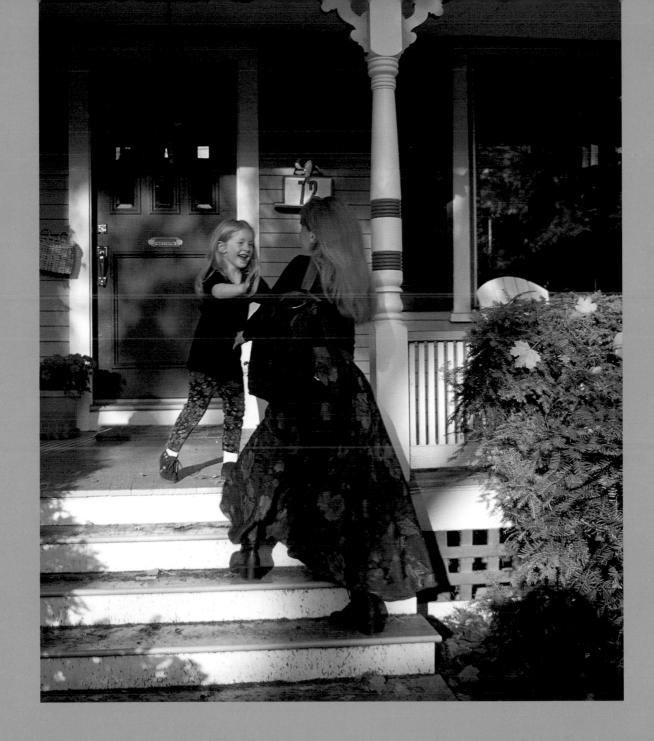

but they always come back.

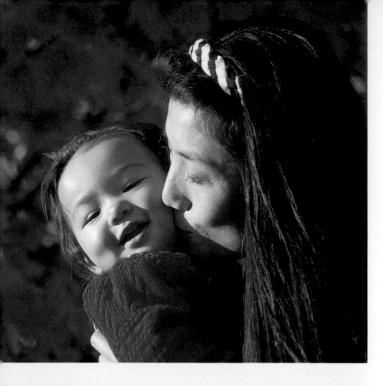

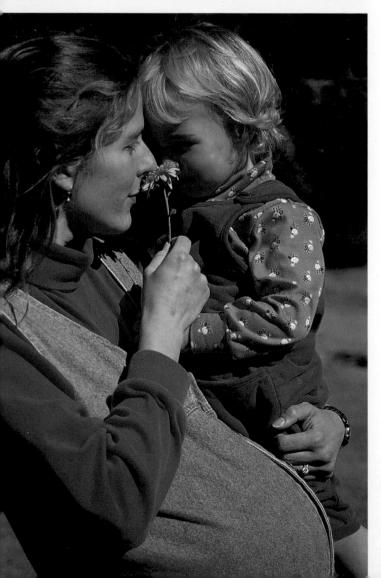

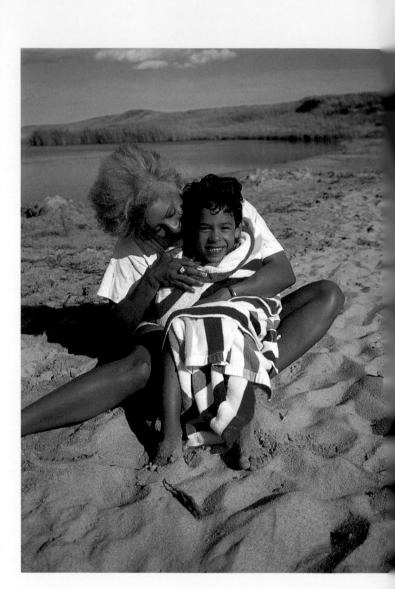

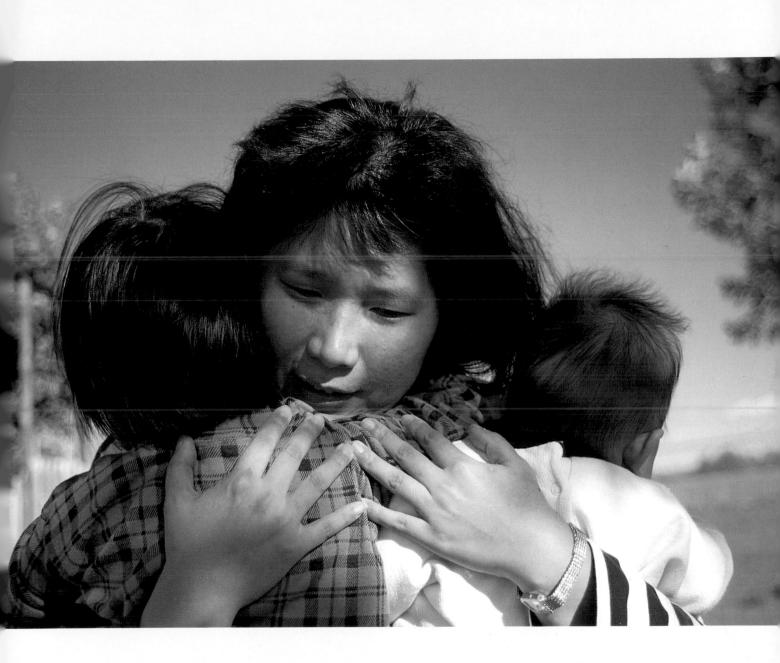

They hug you and smile and say, "I love you."

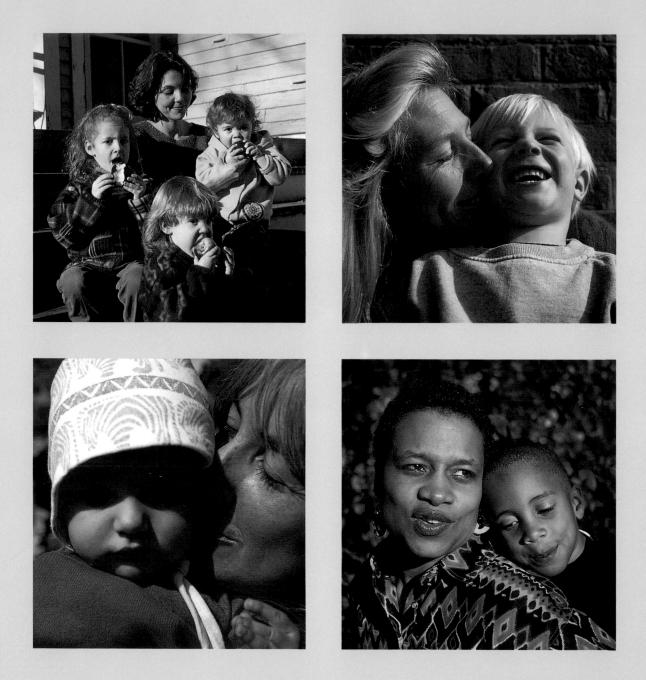

It's good there are lots of moms.